DESPERATE HOUSECATS

DESPERATE
HOUSECATS

by Meredith Parmelee
and Christine N. Roberts

RUNNING PRESS
PHILADELPHIA • LONDON

9 8 7 6 5 4 3 2 1
Digit on the right indicates the number of this printing

Library of Congress Control Number: 2005937396

ISBN-13: 978-0-7624-2855-7
ISBN-10: 0-7624-2855-4

Picture research by Sue Oyama
All photography by Meredith Parmelee.
Photographs provided by Meredith Parmelee/Stone/Getty Images: front
cover, and pp. 7, 18, 20, 23, 26, 27, 31, 33, 38, 47, 50, 54, 60, 73, 75,
76–77, 85, 88, and back cover (left).
Animal training and cats provided by: Silver Screen Animals
Cover and interior design by Melissa Gerber
Typography: Adobe Garamond, Bauer Bodoni, Goudy, and Coronet MT Bold
Special thanks to TB and V-R.

This book may be ordered by mail from the publisher. Please include $2.50
for postage and handling.
But try your bookstore first!

Running Press Book Publishers
125 South Twenty-Second Street
Philadelphia, Pennsylvania 19103-4399

Visit us on the web!
www.runningpress.com

*W*elcome to DewClaw Lane, a pleasant street in the perfect neighborhood. Between apartment buildings and big houses with lovely yards, we have a public garden and many fine shops. With a nail salon and a mini-mart at one end, and a new Senior Center at the other, DewClaw Lane has everything you could want, all on one street! Pretty, safe, and convenient, DewClaw Lane represents the very best of suburban living today.

Feel free to walk around and talk to the residents. They are friendly, easy-going, and interested in whatever everyone else is doing. You'll find they are all very happy to live here! Just watch where you step

—*From "The Welcome Mat: A Visitor's Guide to DewClaw Lane," published annually by Roscoe Inc.*

Aunt Edna watches everything on DewClaw Lane from her position on her front porch. She claims she is just waiting for the delivery of her pet meds, but everyone knows she is really spying on what everyone else is doing.

Nobody knows how long Aunt Edna has been around, or whose aunt she is, exactly. They just know that she misses nothing, and has a different pair of glasses for every occasion.

Aunt Edna has an opinion about everyone and, like shedding her fur, is not afraid to share it.

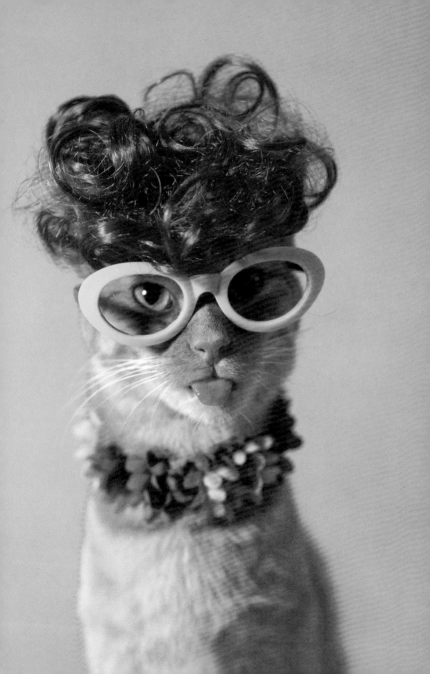

Despite what Aunt Edna thinks, *Queen Sheba* is *really* the Queen of DewClaw Lane. She has been around forever and has seen it all. Rumor has it she was once an alley cat, but no one ever asks her about her past.

Nowadays all Queen Sheba does is lounge about on a special pillow and eat soft food out of a special bowl.

(Needless to say, Aunt Edna thinks she's just lazy.)

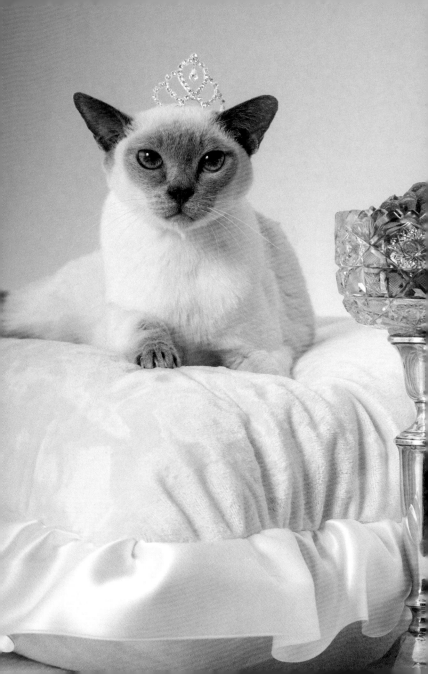

Marilyn has been around the block many hundreds of times. Now she's just tired, because after all of her children who ran away, were given away, or somehow just disappeared, the last two refuse to leave home. So Marilyn is left to constantly clean up after her daughters Audrey and Gracie.

On the other hand, *Audrey* and *Gracie* think life is grand and nine lives are *way* too short! They go to every party, every event, anywhere a pack is getting together. They are out late every night. (Lucky for them, they can sleep in all day.)

Tonight the girls have a special mission: there's a wedding on DewClaw Lane tomorrow, and they don't have dates. What better place to look for some cuties than at the hottest club down the street? They borrowed salmon-flavored toothpaste from their patient mom and decked themselves out for the scene.

They even cleaned each other's ears.

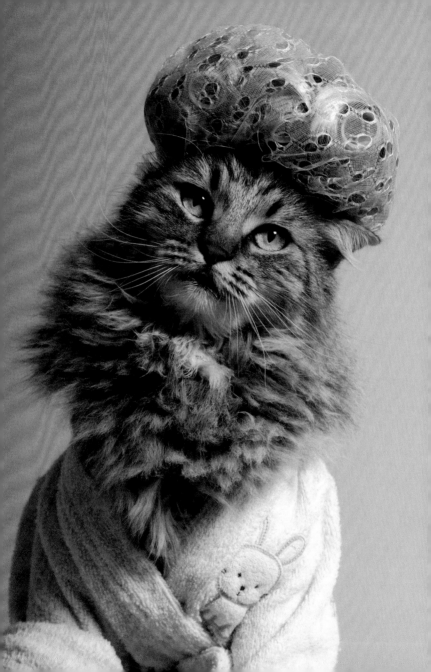

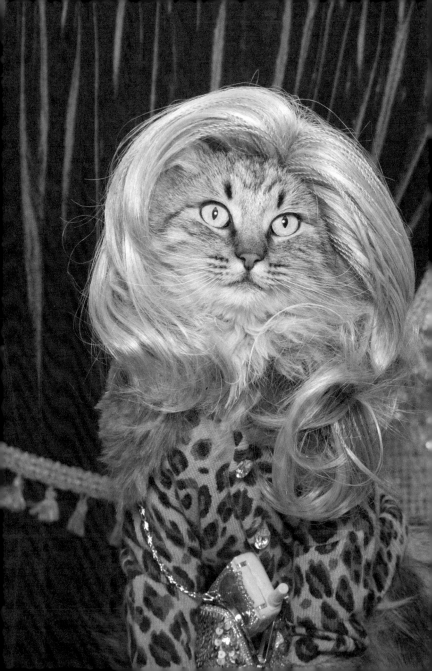

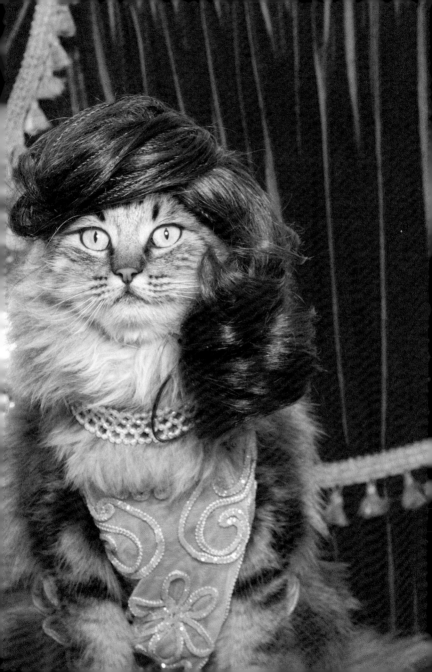

Roscoe is the alpha dog on DewClaw Lane. He considers himself the Mayor of DewClaw Lane, even though cats outnumber dogs 10 to 1 on this street. He's seen it all, and sniffed it all. He can tell where you've been, who you've been with, and what you've eaten.

He is also quite fond of Aunt Edna, although he's never told her.

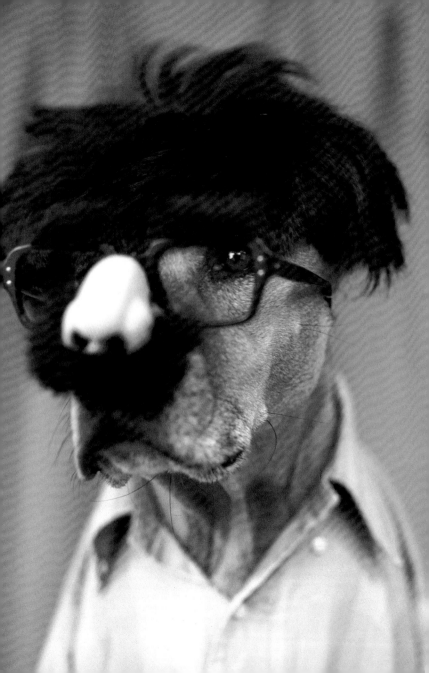

Clementine used to be the hot young thing on the block. But too many litters have taken their toll on her. She is a pure-bred, which means her People like to see her with a new litter. (Apparently it means they will soon have more of this thing called "money." She figures if it makes them happy, they will keep her around.)

Clementine is now expecting another litter any day now. Unfortunately it means she will be too big to fit into her fancy outfit for the neighborhood wedding.

So instead Clementine will probably spend the day tomorrow doing all the things that make her People squeal: she'll stick her nose in a drawer, she'll root around under the staircase, and she'll hide under the bed.

Eventually they will start giving her all sorts of yummy treats and telling her how special she is.

She could really care less about that. She is determined that one of these days, she is just going to have her litter in the middle of their dinner table, and then maybe they'll see how not fun and cute it all is and leave her alone. . . .

Clementine daydreams about the time when she can put her paws up and just enjoy a good long nap or two.

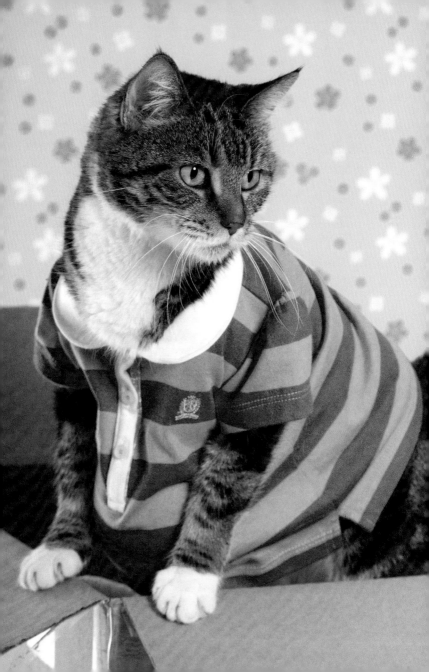

Kitty is young and sweet. She's still very new to the whole being-a-cat thing, and has no idea what's in store for her.

All she knows is that she's crazy in love.

With *Doodle*.

She disguises herself to follow him around all day.

So what if he's a dog?

She thinks it's all very romantic. Just like *Romeo and Juliet*.

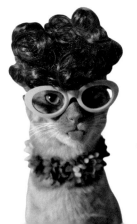

*And we all know how **that** turned out!*

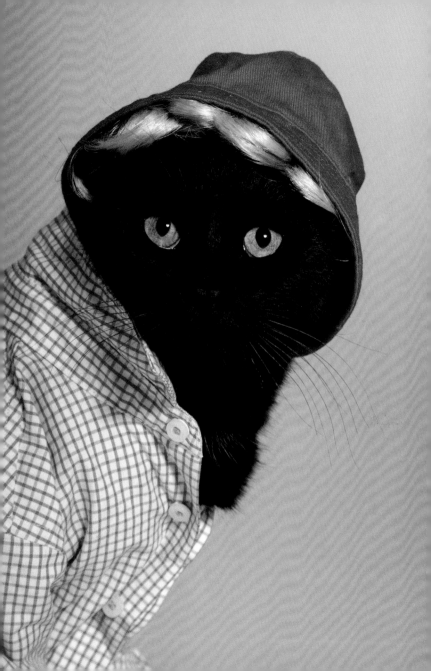

Doodle is not a real Doodle (the Lab-Poodle mix). He just happens to have been named by a very young, very confused Child. His friends remind him that he could have easily been named "Poopie" or "Doodie," so he is learning to like his name.

Because he is very cool.

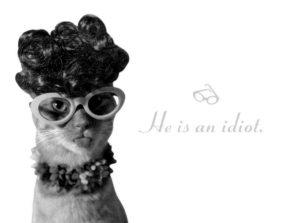

He is an idiot.

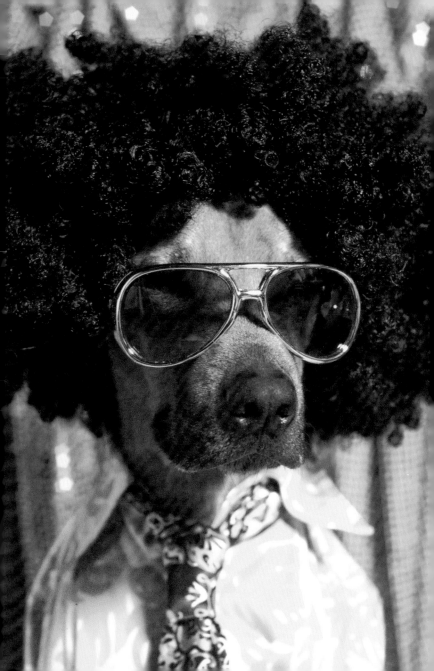

Missy and May—short for Mischief and Mayhem—are sister cats, but they don't hang with the Audrey and Gracie pack. They've been on DewClaw Lane for so long that everyone else assumes they live around there somewhere.

No one has figured out that these two cats don't actually have a home. Missy and May just show up on a doorstep and are taken in for a few days. They stick around long enough to grab some food, a bit of naptime, and use clean litter, then they move on. This makes them quite popular in some households, usually where the People are afraid of something called "a long-term commitment."

All they have to do is stay out of Roscoe's way, because he's made it very clear that he doesn't like strays. He's very particular about keeping DewClaw Lane safe, clean, and licensed.

So Missy and May duck into a store, an alley, or a garden when they see Roscoe coming.

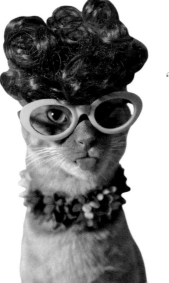

"Long term commitment?" Please. Live nine lives, then you can talk to me about long-term.

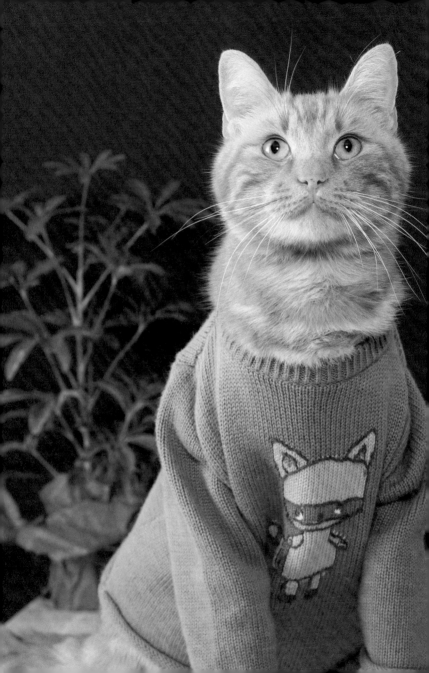

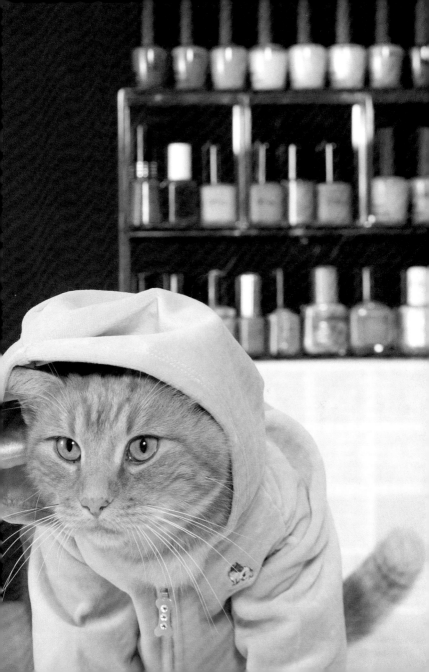

Fluffy, on the other hand, could care less how other cats behave. Despite her fussy appearance, she is quite fond of this thing called "punking" the other cats. She will leave dog treats in cat food bowls, pounce on unsuspecting kitties as they cross her yard, and her favorite trick is to brush up against a Person's legs.

Particularly a Person wearing dark pants.

"Because really, who's going to yell at a face this adorable?" she asks.

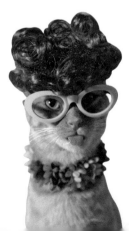

A little less time looking in the mirror, and a little more time actually digesting her own fur would be much appreciated by those of us who have to walk around here!

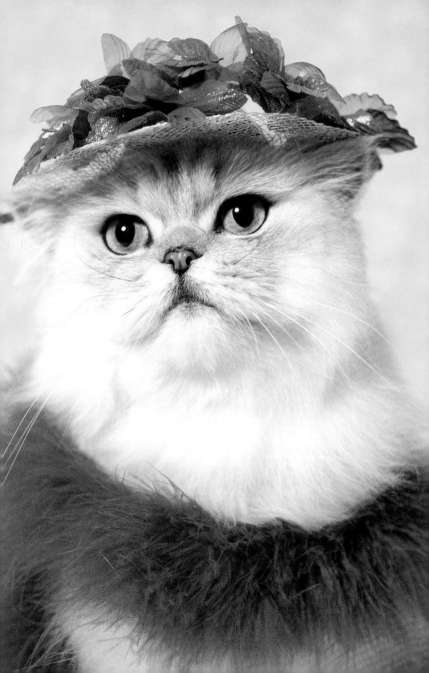

One of Fluffy's favorite targets is *Jumpy*. Nobody remembers Jumpy's original name, because for as long as anyone can remember, she's been skittish. She jumps at the slightest noise or light or question or howl. She's been known to jump sideways, sometimes face-first into a wall.

None of the other cats has ever tried to calm Jumpy down. They just accept the fact that she is high-strung. Fluffy takes advantage of this, but the other cats on DewClaw Lane are content to let Jumpy be.

Of course, if anyone asked her about it, Jumpy would say that she's afraid because she's seen the *other* cat that lives in her house. It's always in the same place, with the same angry look on its face.

She doesn't know why the People in the house let that cat sit up on the mantel all day, but she's sure to give it a wide berth whenever she has to walk through that room. *There's just something creepy about a cat that doesn't seem to get any older,* she thinks.

And it doesn't seem to mind being dusted, either.

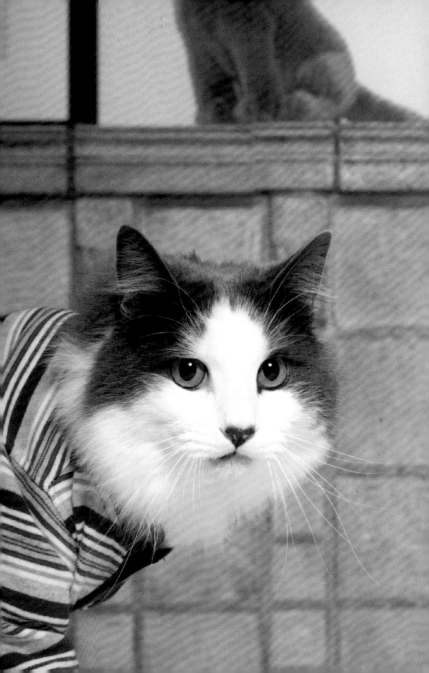

Jumpy has gone to see $\mathcal{D}oc$, but she's never told the kindly older cat about the other creepy one in her house.

At first Doc suggested Jumpy get some therapy. But after she scratched the therapist's couch too many times, the therapist sent her back to Doc to get some sedatives.

Doc has prescribed many, many pills to calm Jumpy down. In an effort to be "A Better Pet," as Doc encourages her to be, Jumpy accepts the pills.

But she never wants to relax when she's at home—because the evil glare of that other cat seems to follow her everywhere in the room—so she just buries the pills in her backyard.

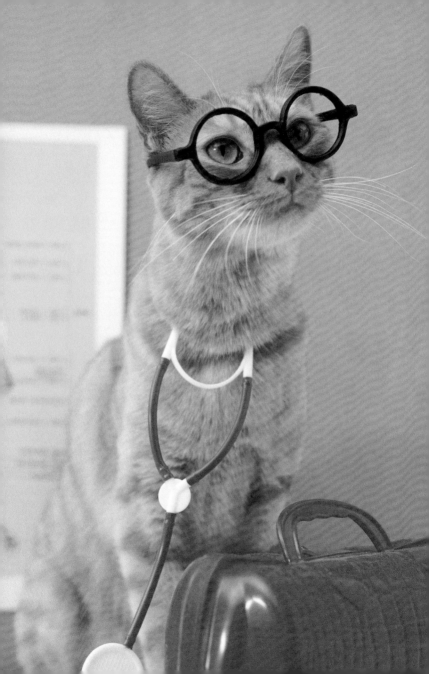

Aunt Edna thinks all the young kits on the block should be more productive members of their society. After all, cats have a long tradition of being noble, regal, and aloof.

"We're the *alpha-dogs* of the domesticated set," she'll tell anyone who listens.

But since none of the other cats can understand how a cat can also be a dog, they tend to pat her on the head and go about their business of sleeping, eating, and cleaning themselves.

Aunt Edna can't believe what some cats let their People do to them.

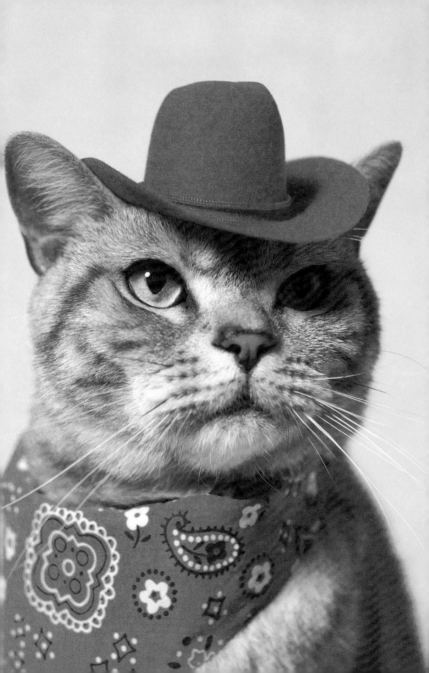

This is *Zoey*.

Zoey likes to take naps.

A lot.

The other cat in Zoey's house is *Ferdinand*. He likes to take naps too, just not as many as his litter-mate Zoey. He can usually be found curled up somewhere small and confined, like in the family's patio grill, or in an open drawer.

The problem is that Ferdinand is not a tiny cat. He has been known to get stuck in some tiny places.

The only time Ferdinand is not sleeping in a tight spot is when one of his People goes fishing.

Then he is the first one in the boat.

Which sometimes results in the boat tipping over.

Meet *SarahCat*. She is actually a *boy* cat, but the Little

Girl who named her thinks all cats are girls.

She likes to dress the kitty up in doll clothes and take her for

a walk in her doll carriage.

Because the Little Girl is so nice, and pets SarahCat so gently,

he has decided to put up with a girl's name and wearing the doll

clothes.

Sometimes he is less patient than other times, though.

*In my day all cats were named Tiger,
regardless of whether they were boys or girls.
There would be eight or nine of us sharing one
box. We had to run up trees just to get firemen
to rescue us. Our People were proud of us if
we left a mouse on their doorstep; we were
expected to do it again and again!
Cats today have no sense of how easy they have it.*

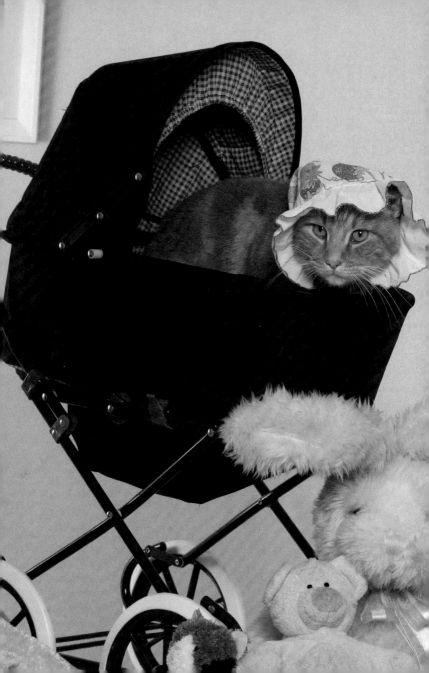

Compared to the girlie life of SarahCat, the boys next door are quite rough and tumble. *Guinness* has been partying quite a bit with some catnip, and now he is trying to drink a lot of water so he can act normal. He does not want to go to the neighborhood wedding tomorrow feeling sick.

(Truthfully, he does not want to be sick ever. Because sick cats go to a Person called a Vet who likes to take their temperature. Guinness has heard that this is *not* a fun time.)

So Guinness creeps around very quietly, hoping he can just drink a lot of water and sleep it off.

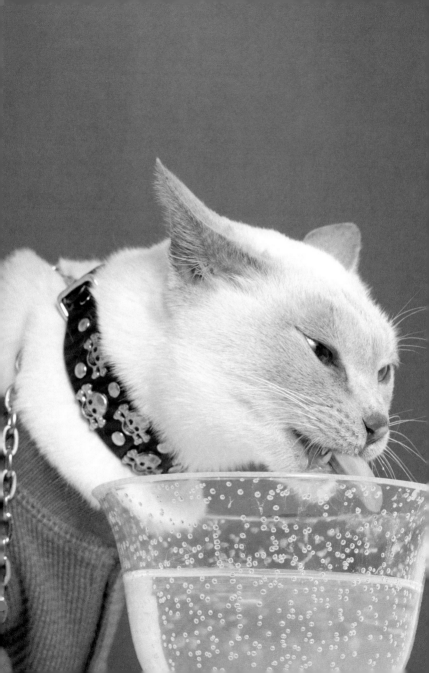

Guinness's brothers, *Bud* and *Jaegermouser*, also had a lot of catnip. For a while they chased each other's tail, and occasionally their own, but then Bud and Jaegermouser settled down in the middle of the sidewalk to look at the sky.

For a very long time.

The boys talk about Audrey and Gracie, and whether or not the sisters are going to the wedding.

"The party of the month?" Bud asks. "Of course they'll be there!"

"I don't know," Jaegermouser says. "Sometimes those girls act like we're just tomcats, and they won't come near us."

"Hey, I like a good meow at the moon as much as the next cat," Bud admits. "But that doesn't make me some stray."

"True," Jaegermouser says, already forgetting what they were talking about while he contemplates his front claws. "Look!"

he exclaims. "They go in and out!"

Bud watches his brother stretch out a paw and flex his claws. He is pretty sure that their claws always did that, but he isn't thinking too clearly.

He is hungry.

Very hungry.

Right now very hungry.

"Dude, let's get some food!" he says.

Jaegermouser jumps up. "Munchies!" Jaegermouser is always looking for food. He'll whine and rub against a Person's leg, until fresh food is set out for him. He may only eat a bite a two, but that isn't the point. The point is for the Person to provide him with food.

Preferably the kind that requires a can opener.

Bud nudges his brother and the two cats set off for the Grub Grab-n-Go.

It's very early on the morning of the wedding, and *Gracie* and *Audrey* are trying to creep back into their house before their mom Marilyn sees them. They don't really remember much about the club, or if they lined up dates for the wedding.

All the sisters know is that they aren't wearing the same collars they went out in last night.

If their mom Marilyn finds out, the girls will have to listen to another lecture about how she too used to run around with a bunch of Toms, and now look at her. Several litters later, her People had to take her to the Vet.

Now she can't sleep or eat enough, and something as simple as a shoelace amuses her.

Marilyn doesn't want that to happen to her youngest daughters. She wants them to be debutantes or models or some other productive member of society.

Instead she's afraid they might end up with a string of broken engagements, a dependency on catnip, and maybe a reality show on The Animal Chanimal.

The girls have heard this all before.

They just roll their eyes.

Those girls will come to a bad end, mark my words!

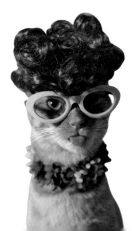

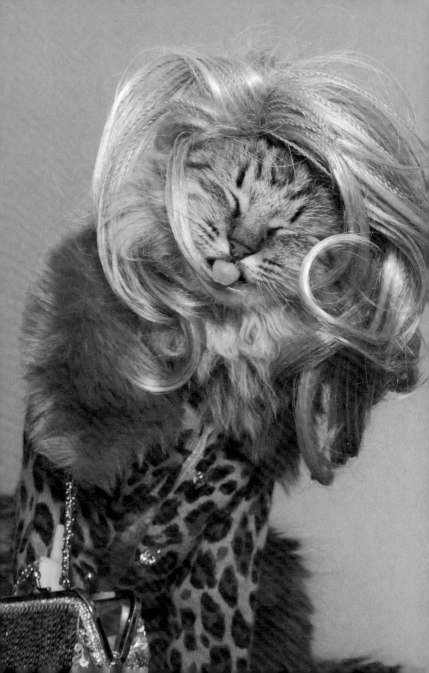

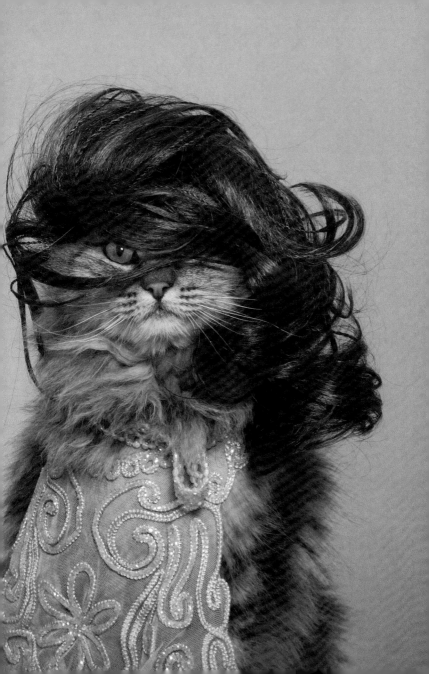

PussPuss was also named by a Very Young Child. She doesn't understand what it is with People—naming their cats after TV stars, or letting Little Johnny give a name to an animal who is cleaner, quieter, and more hairy than he will ever be—but she puts up with it.

Because it's not in her nature to be difficult.

So she hangs out in the garden during the day, helping her people by digging holes for them, or bringing them little presents she finds out there.

She feels very in tune with Nature. She thinks maybe she was a gardener or a snail in a previous life.

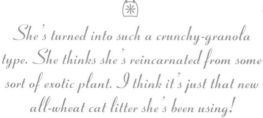

She's turned into such a crunchy-granola type. She thinks she's reincarnated from some sort of exotic plant. I think it's just that new all-wheat cat litter she's been using!

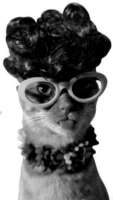

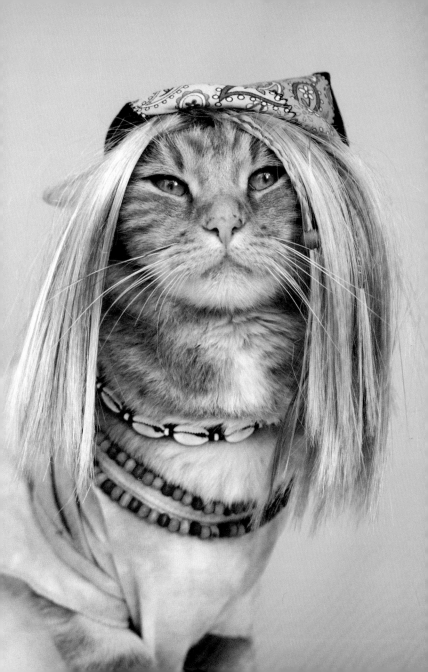

Bruno is Roscoe's oldest friend. They've known each other for at least 3 years, though it feels like 21.

Whatever Roscoe needs done, Bruno does it. He helps Roscoe keep the peace on DewClaw Lane. If an animal from another neighborhood tries to leave something around a tree or fire hydrant on DewClaw Lane, he will chase them away and cover up the crime.

And if Bruno has nothing to do for Roscoe, he spends his time getting between squirrels and their home tree. (He knows nothing drives a squirrel more crazy than to be caught out in the open and unable to retreat to their favorite perch!)

Today Bruno is worried about some alley cats crashing the big wedding. He's pretty sure they won't come over to DewClaw Lane during the day, but Roscoe asks him to keep an eye out just in case, so Bruno puts on his best hat and goes on patrol.

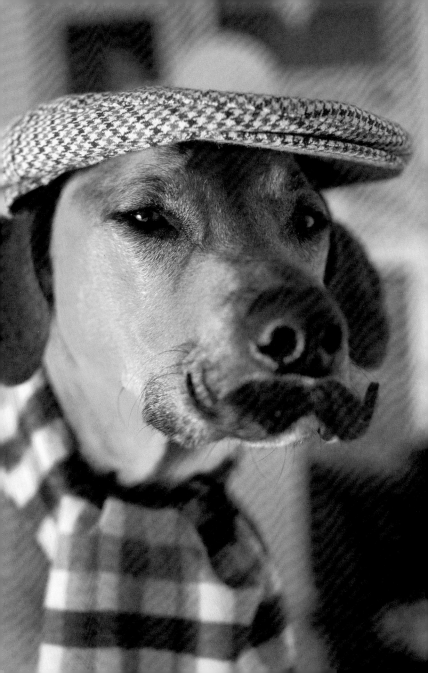

Kitty is surprised to learn that her People want to take her to someplace called the Vet's. Apparently this is going to be a "big day" for her. She is very excited. She doesn't know what this means, but she is sure it will be a life-altering experience.

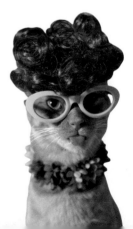

Oh, something will be altered, that's for sure!

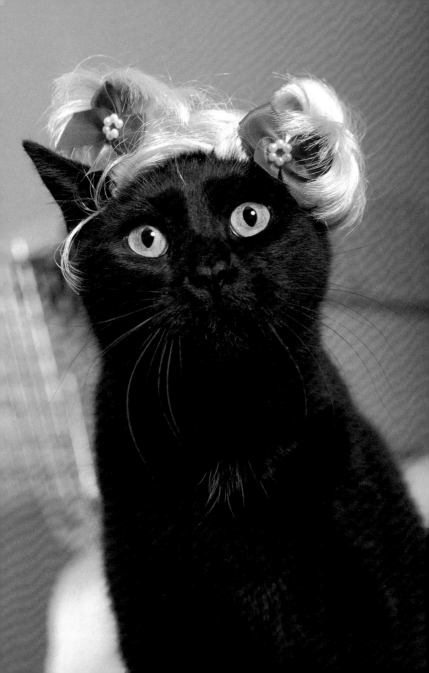

Zoey has rolled over.

Ferdinand is always impressed by his sister's ability to follow the sun across the couch without ever appearing to wake up.

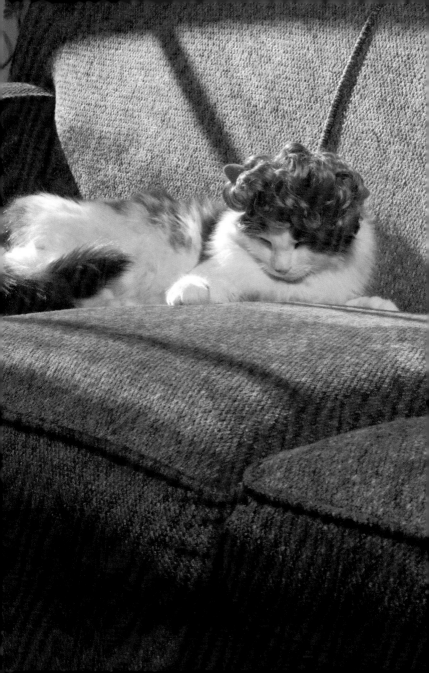

Gizabelle is an indoor cat. She doesn't go out in the yard or even on the front porch. (She has heard her People say that fleas can jump three stories high!)

She is content to sit in her window and watch all the other cats risk their fur by playing in the grass, scratching their backs on the sidewalk, digging in the gardens, and poking about in the trashcans.

She would rather sit on the windowsill, just sniffing the fresh air.

This means she doesn't have to wear a collar, so Gizabelle is free to scratch her neck with her back paw whenever she wants.

She is very pleased by this ability, and knows that if she were ever entered into a cat contest of any sort, she would be sure to win first place.

And maybe a can of tuna.

Mmmmm

Gizabelle is very good at covering up her drool by cleaning herself. *A lot.*

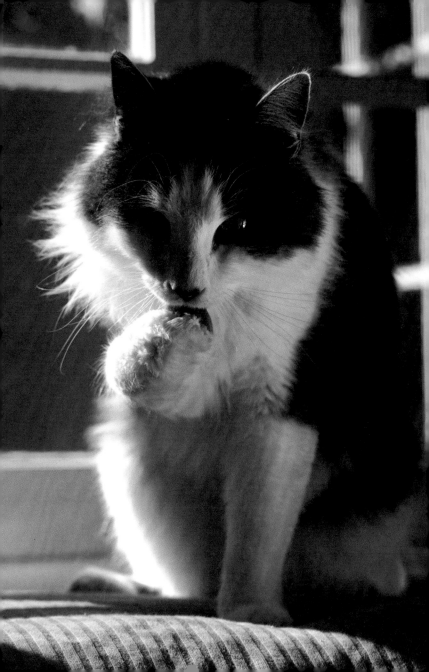

Ferdinand loves *Gizabelle*. When he isn't sleeping or stuck in a flowerpot on the deck, he watches her up in her window, while she watches the street.

He thinks she is very pretty. And that she must have a tragic past—or pasts—to stay inside all the time.

His Person is going fishing today, so although it means he will miss the big wedding, he is happy to think he might catch a fish that he could bring back for Gizabelle.

Ferdinand isn't too sure how he'll get the fish out of the water, or back to DewClaw Lane, or up to Gizabelle, but he's pretty sure that if he just sits in the very front of the boat and stares at the water very hard, an answer will come to him.

I'm very sure that if he sits in the very front of the boat, the boat will soon be upside down and the fish will be very safe from him!

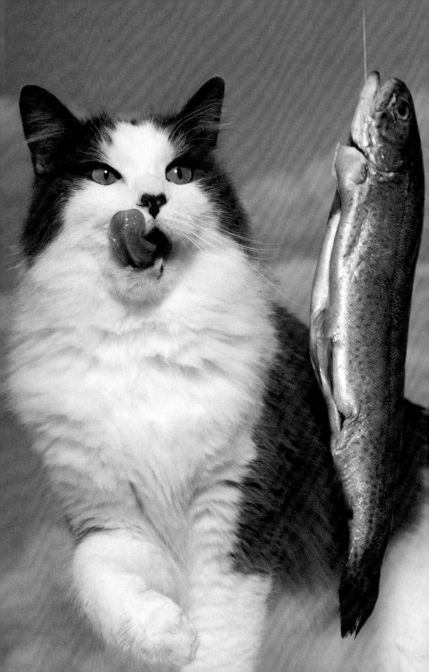

SarahCat has decided he doesn't want to wear a dress to the wedding today, so he is hiding from his Little Girl.

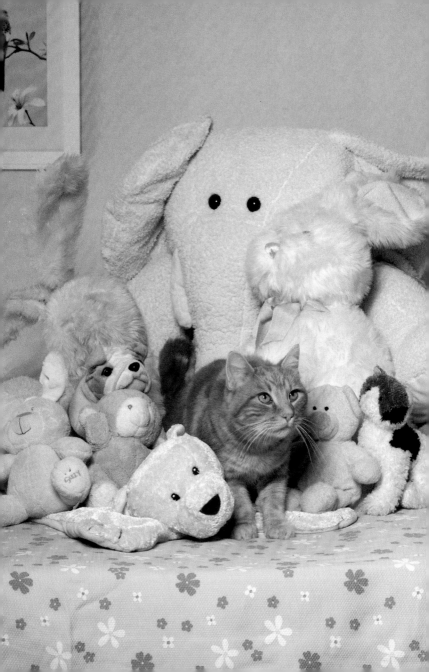

Marilyn meets with *Clementine* at the nail salon. The mothers plan to get their claws trimmed, and maybe capped in those new nail caps, before Marilyn goes to the wedding today.

It's the little things that make a cat feel special, Marilyn tells herself.

Marilyn tells Clementine that Aunt Edna has been spying on her again. The old biddy actually told Marilyn she was a bad mother for letting her girls run all over the alleys at night.

Clementine tells Marilyn not to have a litter over it. She is sure that Aunt Edna will be distracted by something else before she can spread the gossip.

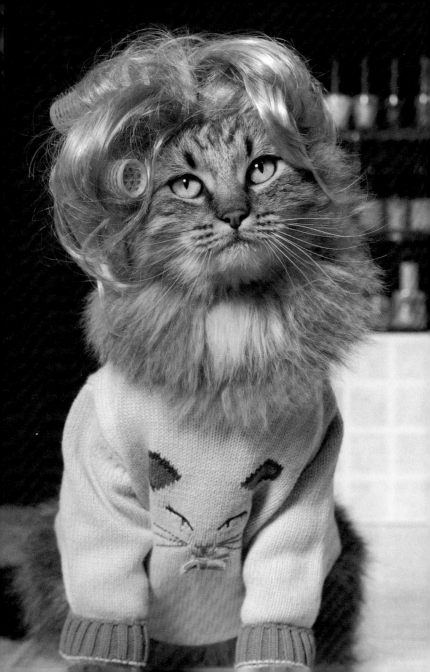

Rocky hears about Marilyn's distress when Clementine stops by after her trip to the salon.

"I assure you," he tells Clementine, "Aunt Edna is merely keeping an eye on things around here. In a way, she is a Town Watch unto herself. Nothing happens here that she doesn't know about. Really, it keeps us all safe."

Clearly Rocky is not too worried about the harmless old lady. He's just found a spot on his back that he couldn't reach, and that disturbs him quite a bit more than whatever Aunt Edna is up to.

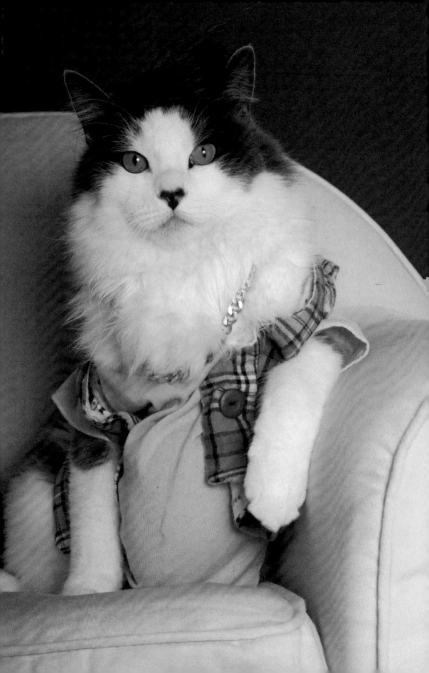

Gizabelle is at her window, as usual. She sees Jumpy creeping around her People's house, acting very secretive. Gizabelle wonders what Jumpy is up to, but she can't follow the skittish little cat, because that would involve going Outside.

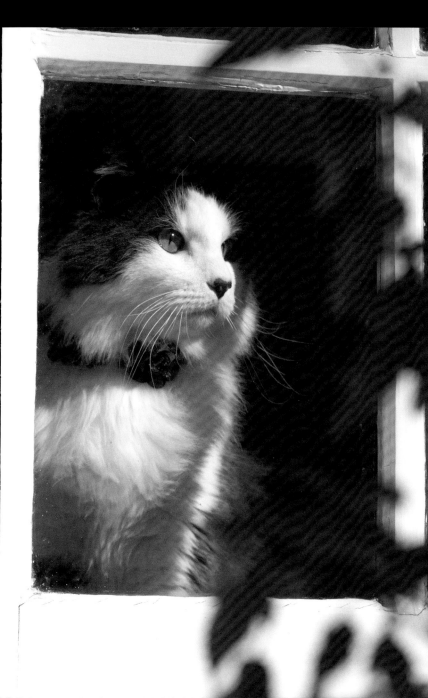

Aunt Edna is on her front porch, as usual. Though she is really just waiting for the morning paper to sit on, she manages to turn her head far enough that she can see *Jumpy* go into the garden and start digging. Aunt Edna shakes her head. Jumpy must be burying another one of those pills. *Silly People*, Aunt Edna thinks, *don't they realize that cats can hold a pill in their mouths for a long period of time and not swallow it? Why, I bet if I dug up Jumpy's pills, I could still read the name on them! Why don't they just hide the pill in Jumpy's food? You could push a pill deep into a soft treat and the poor cat would never know.*

Boy, Aunt Edna thinks, settling back down to wait for the paper, *I wonder just how many of those pills Jumpy has buried by now. . . .*

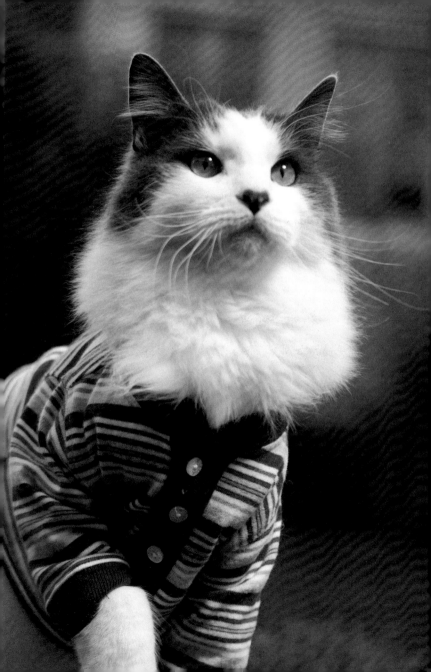

This is *Tina*. She is a very pretty cat. The Child in her house really loves Tina. She especially loves to dress Tina up.

In a wedding dress.

And to dress *Tony* up in a little tuxedo.

They are getting married. Again.

So the Child is fitting the dress on Tina.

Again.

Tina is patient with the Child. She knows People need a lot of attention, patience, and care.

Sometimes Tina wonders what would happen to People if they didn't have cats around to take care of them. . . .

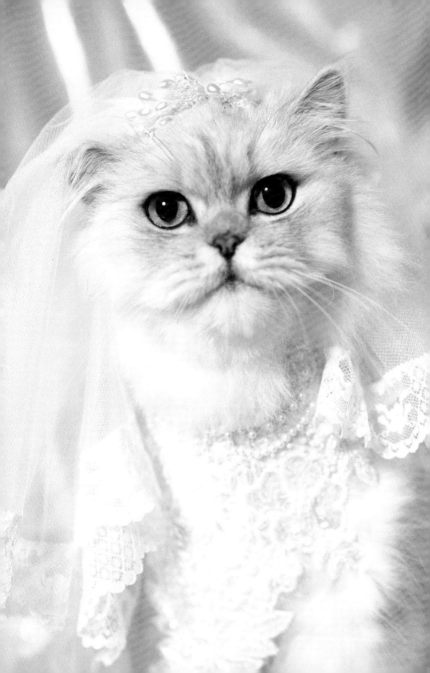

The Child loves to play Wedding Day with her cats *Tony* and *Tina*. She throws a little party and all the local cats come over for treats and to wish the new couple a happy life or two.

Tony and Tina have fun at the party and enjoy the treats. It almost makes up for the fact that the Child seems to marry them at least once a month.

No one has explained to the Child that Tony and Tina are brother and sister.

How ridiculous! If they asked me, I would happily tell their People that none of us really likes going to the monthly wedding. I can't imagine what we'll do when their Child starts to like other things, like horses, and fairies, and make-up. What will she subject us to then? I wish everyone would just leave me alone so I can watch the Animal Chanimal in peace!

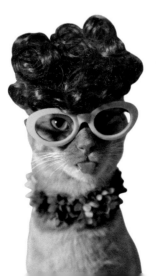

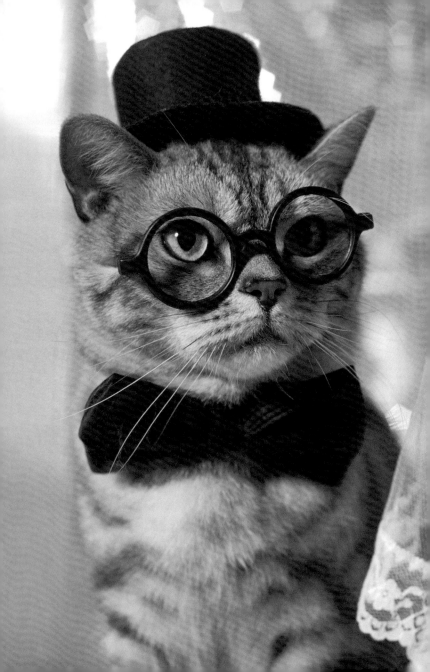

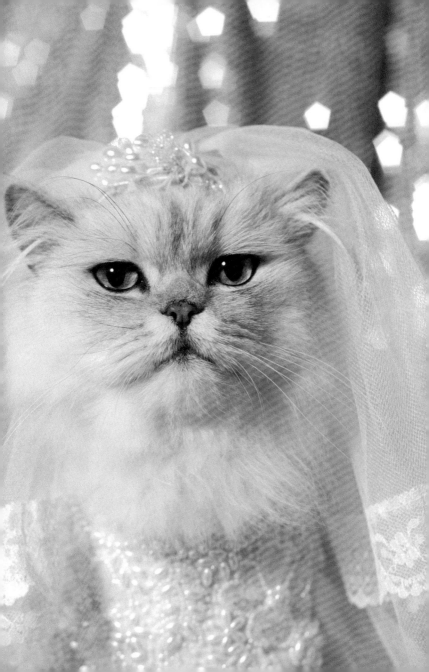

Clementine has spent the morning poking around the house, trying not to notice her People quietly following her around. She settled into a box they left under the stairs, and the People finally went away.

But now they are sitting down to lunch at their nice, big, clean kitchen table and she's ready to have her litter. The timing couldn't be better. . . .

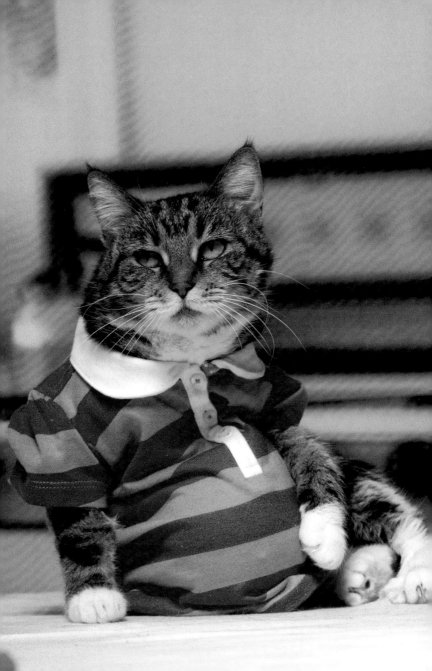

PussPuss has been poking around in her garden, trying to find the perfect flowers to take to the wedding. She does not want to go to the party empty-pawed.

There's a fresh hole in the garden. PussPuss is sure she has identified every hole several times, so this one is new, and more important, not hers.

She sticks her nose in the hole, but it is empty. *Hmmmm,* she wonders. *What was in here?* She thinks about all of the things she has buried recently, and realizes she didn't bury anything here.

So what was in this little hole?

PussPuss sees another new pile of dirt further down the garden and goes to investigate.

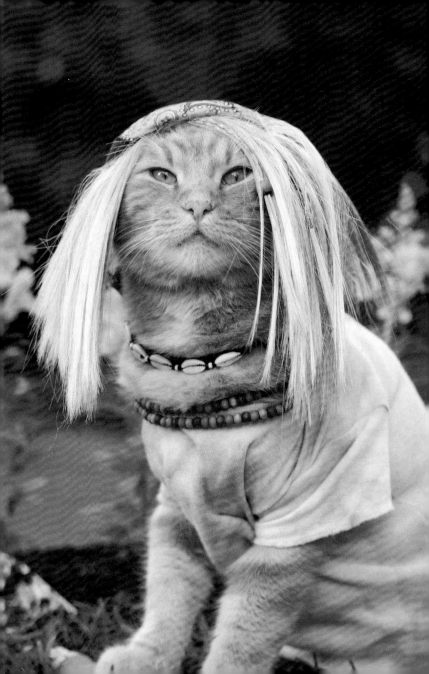

Edith was at the salon this morning, getting her monthly highlights and grooming. Now she has gone up and down the street to be sure everyone will be at the wedding. The only cat she can't find is Queen Sheba. This is very odd, since everyone knows that Queen Sheba is *always* on her special cushion, in front of her special bowl, filled with special food, or playing with a special toy.

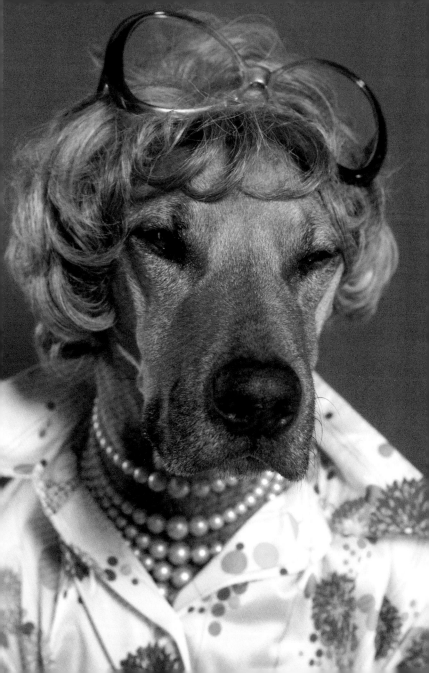

Roscoe and *Bruno* start to question everybody about where they were before the wedding and if anyone had seen Queen Sheba.

But everyone has an alibi:

Kitty is still at the Vet's.

Zoey is still sleeping.

Ferdinand is still fishing.

Gizabelle still has not left her window.

Clementine is still having kittens.

Audrey and *Gracie* are still asleep.

Marilyn's claws are still drying, so she's useless.

Sarah Cat is still hiding.

Tony and *Tina* were being dressed for their wedding.

(Again.)

"What about those sisters, Missy and May?" *Aunt Edna* asks. She tells them all that she was visiting Queen Sheba this morning, and when she came out, she thought she saw them slinking away in the garden.

Nobody has seen PussPuss either.

Doodle volunteers to go look for the two sisters, while Bruno searches for PussPuss.

The brothers *Bud*, *Guinness*, and *Jaegermouser* are still a bit out of it, and don't remember who Queen Sheba is.

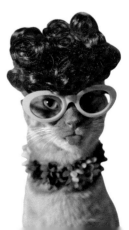

I'm shocked—shocked— that anyone does not know who Queen Sheba was. Is. I mean is.

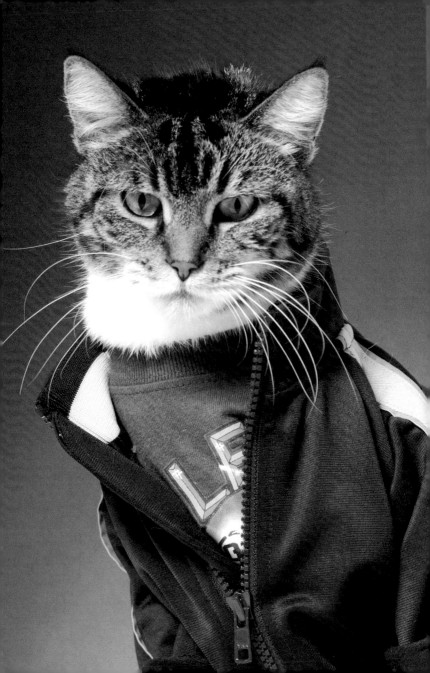

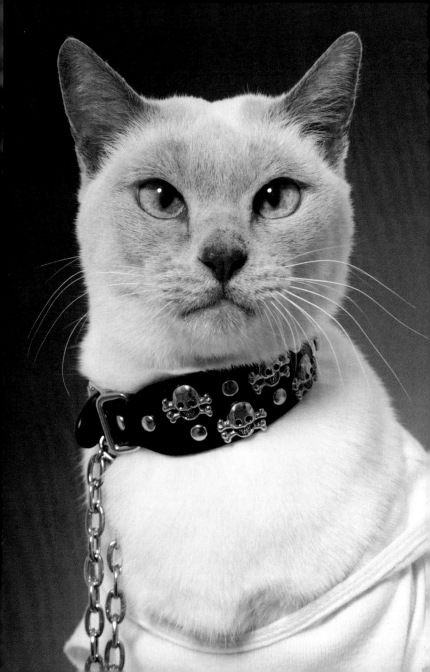

Doodle finds *Missy* and *May*. It turns out that they have a new home at the DewClaw Lane Home for Seniors. They will never have to move again. They will always be fed and played with.

They will always have an endless supply of yarn.

And best of all, no one cares where they came from.

Once they tell Doodle their story, he understands that the sisters would not have done anything to *Queen Sheba*. Why would they want to mess up a good situation on the same street where they will live for many more lives?

I am a very smart dog, Doodle thinks.

Doodle, here's a quarter.
Buy a clue.

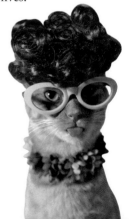

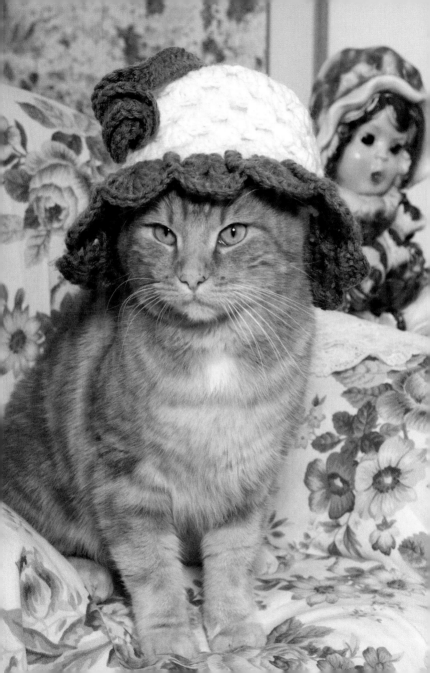

Down the street *Bruno* has found *PussPuss*, and she is very upset. She needs to talk to Roscoe right now.

She found Queen Sheba.

Buried in the garden.

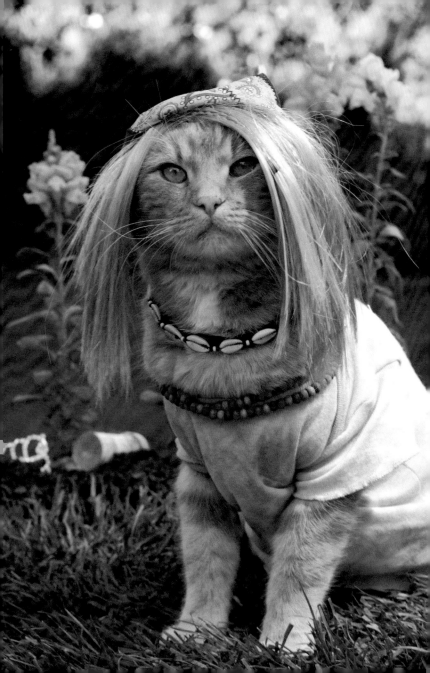

Queen Sheba is dead.

Roscoe tells all the cats of DewClaw Lane. Everyone is very sad about this.

"What happened to her?" *Jumpy* asks, looking around nervously.

Roscoe explains that Queen Sheba was very old. She probably just died in her sleep.

Fluffy tells everyone she heard her People say Queen Sheba was found facedown in her special bowl of soft food.

Now the cats are very curious about this turn of events.

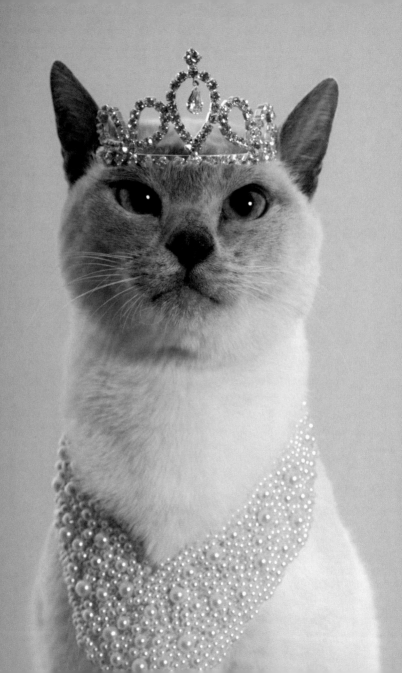

Before she goes back to her spot on her porch, Aunt Edna reminds them what happens to cats who get too curious.

So they all scamper off.

Everyone agrees, though, that *Aunt Edna* looks very nice in her new crown.

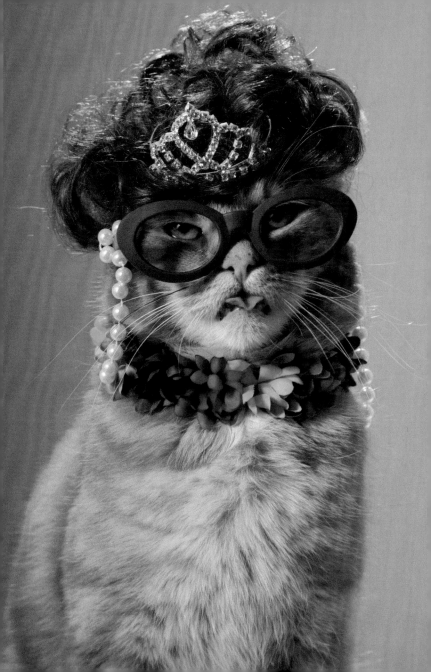

Meredith Parmelee grew up in the San Fernando Valley with a freeway in her backyard. A fine arts and photography graduate of the Art Center College of Design in Pasadena, she has been an independent artist for the last 16 years. Known for her series of dressed-up dogs, her quirky focus and vibrant color schemes draw smiles at first review, but behind the simple images, her works show a sardonic take on life's assumptions—what appears soft and fuzzy is often a bit twisted upon closer review. (Not unlike the backyard adjacent to a freeway.) Working primarily in the advertising and editorial fields, Meredith has received both a Maggy and a Belding award for her work. She has been a contributing artist for the charity organization PAWS LA, and was profiled in *Fido Friendly Magazine*. Meredith's work has been shown in many galleries and collections. Worldwide distribution of her stock images available through Getty Images and Workbook Stock. You can visit her at www.meredithparmelee.com.

Christine N. Roberts is a writer, editor, and couch potato. She is grateful for her deluxe electric can opener, but looks forward to the day that cats develop opposable thumbs.

She has been owned by several cats over the course of her current lifetime.